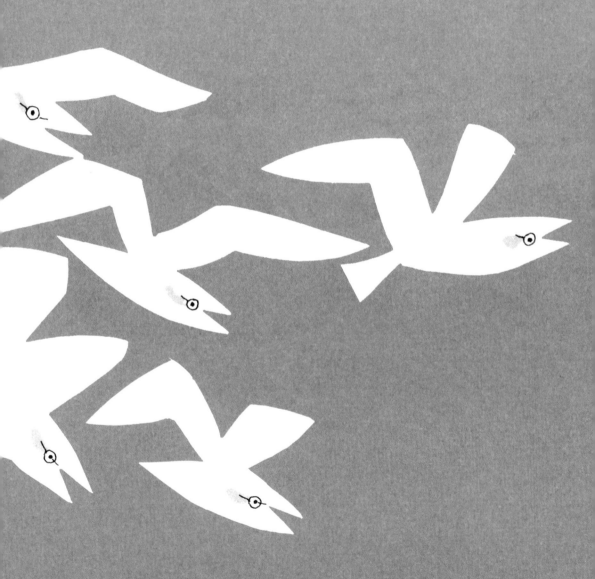

Enchanted Lion Books gratefully acknowledges the support
of NORLA for the translation and publication of this book.

First English-language edition published in 2019 by Enchanted Lion Books
67 West Street, 317A, Brooklyn, NY 11222
Originally published in Norwegian in 1971 as *Den sommeren*
Copyright © 1971 by H. Aschehoug & Co. (W. Nygaard) AS
Published by agreement with Oslo Literary Agency
Copyright © 2019 for the English-language edition by Enchanted Lion Books
Translation Copyright © 2019 by Enchanted Lion Books
Handlettering, production & layout: Julie Kwon

Library of Congress Cataloging-in-Publication Data
Names: Hagerup, Inger, 1905-1985, author. | Gauguin, Paul René,
illustrator. | Crook, Becky L., translator.
Title: That summer / by Inger Hagerup; illustrations by Paul René Gauguin; translated from
the Norwegian by Becky L. Crook.
Description: First English-language edition. | New York: Enchanted Lion
Books, 2019. | Audience: Ages 8-12. | Audience: Grades 4-6. | Summary:
"A collection of poetry for children written in free verse by Norwegian
poet Inger Hagerup and illustrated by Paul René Gauguin"– Provided by publisher.
Identifiers: LCCN 2019025655 | ISBN 9781592702770 (hardcover)
Subjects: LCSH: Children's poetry, Norwegian–Translations into English. |
CYAC: Norwegian poetry.
Classification: LCC PT8950.H258 A2 2019b | DDC 839.821/74–dc23
LC record available at https://lccn.loc.gov/2019025655
Printed in China by R. R. Donnelley Asia Printing Solutions, Ltd.

First Printing

THAT SUMMER

BY INGER HAGERUP

ILLUSTRATIONS BY PAUL RENÉ GAUGUIN

TRANSLATED FROM THE NORWEGIAN
BY BECKY L. CROOK

ENCHANTED LION BOOKS
NEW YORK

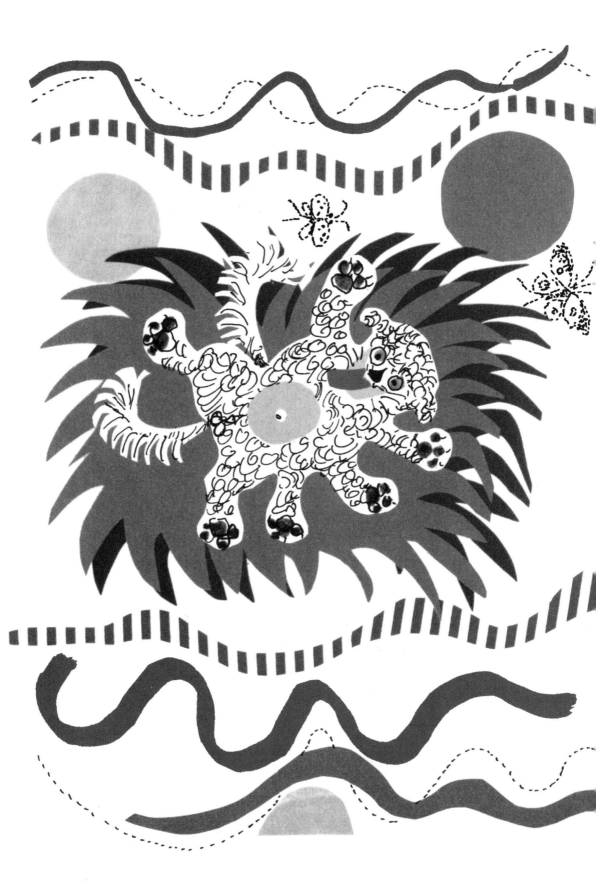

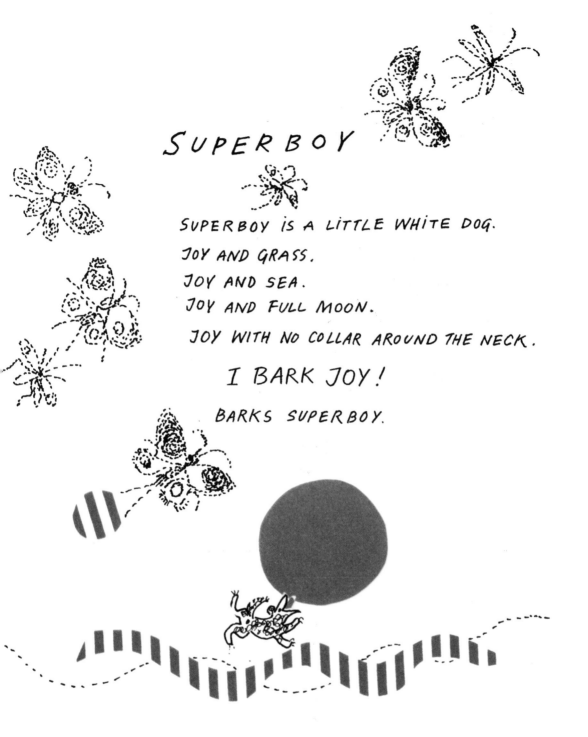

SUPERBOY

SUPERBOY IS A LITTLE WHITE DOG.

JOY AND GRASS.

JOY AND SEA.

JOY AND FULL MOON.

JOY WITH NO COLLAR AROUND THE NECK.

I BARK JOY!

BARKS SUPERBOY.

THE BEETLE IN THE ROSE

IN THE INNERMOST FOLDS
OF A RED ROSE
LIVES A GREEN BEETLE.
GREEN AND RED
TASTE GOOD TOGETHER,
THINKS THE BEETLE.
IF IT THINKS
GREEN AND RED.

THE ANT

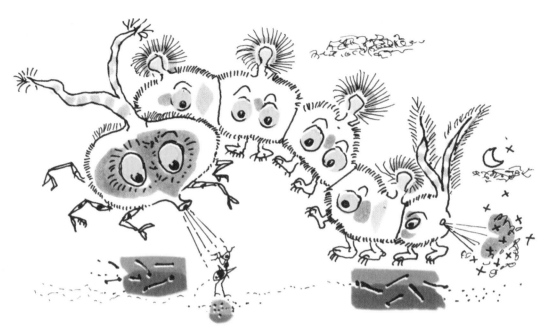

LITTLE?
ME?
FAR FROM IT.
I AM EXACTLY THE RIGHT SIZE.
I FILL MYSELF OUT JUST SO,
LENGTHWISE AND WIDTHWISE,
FROM BOTTOM TO TOP.
DO YOU THINK _YOU_
ARE BIGGER THAN YOURSELF,
PERHAPS?

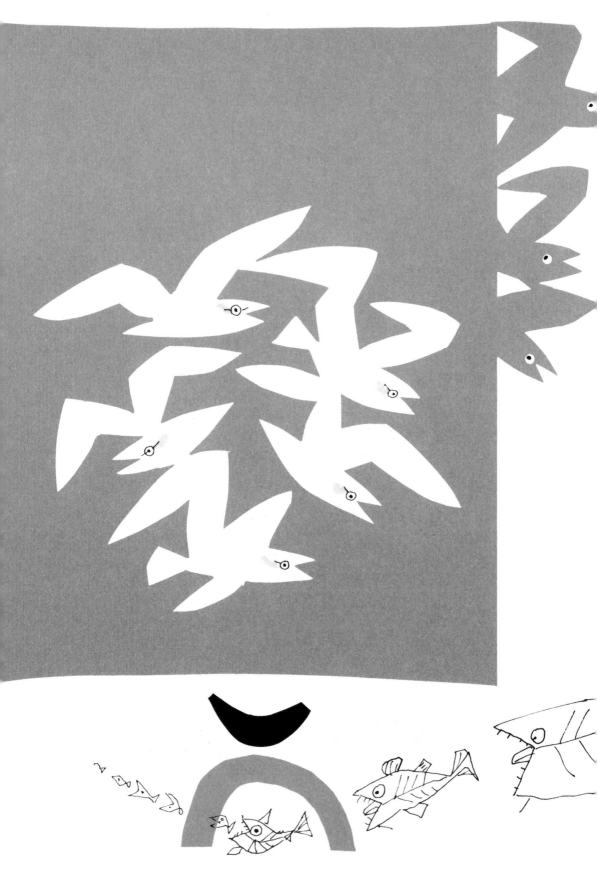

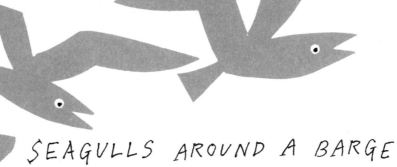

SEAGULLS AROUND A BARGE

●

SORRY, SEAGULLS,
WE HAVE NO FOOD FOR YOU TODAY.
MAYBE TOMORROW...

Food!

FOOD!!

SCOLD THE SEAGULLS
IN SEAGULL-
SPEAK.

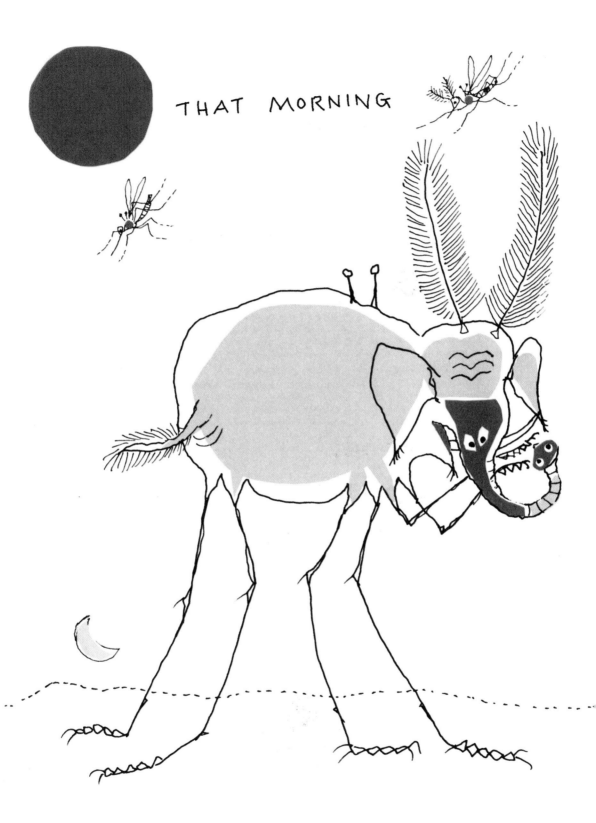

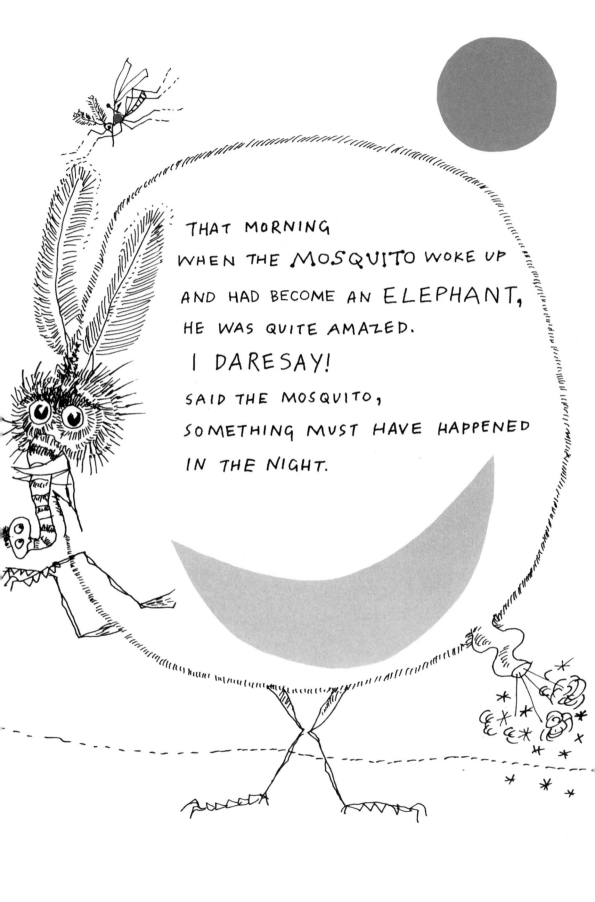

THAT MORNING
WHEN THE MOSQUITO WOKE UP
AND HAD BECOME AN ELEPHANT,
HE WAS QUITE AMAZED.
I DARESAY!
SAID THE MOSQUITO,
SOMETHING MUST HAVE HAPPENED
IN THE NIGHT.

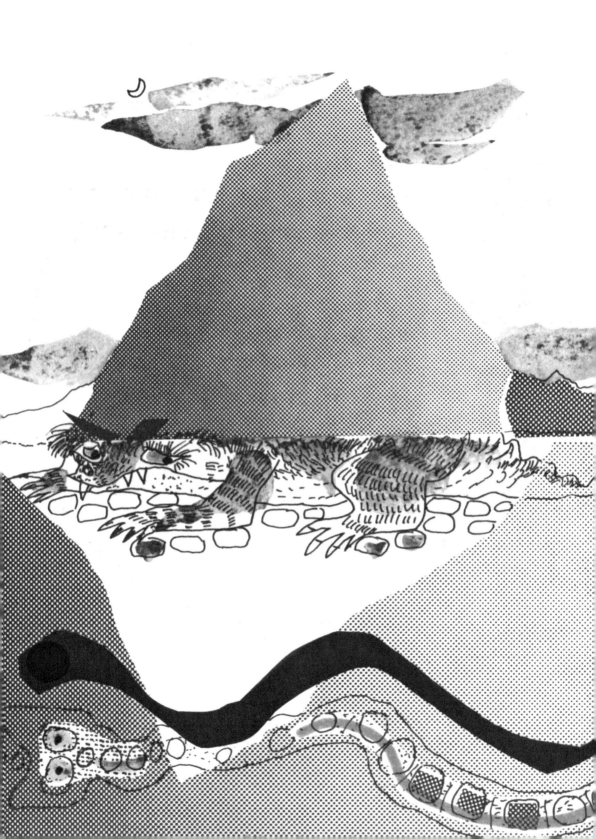

THE OTHER DAY

THE OTHER DAY
MOUNT GALDHOPIGGEN MOVED
BY ALMOST AN INCH.
IT WAS A CHORE
IT HAD BEEN DREADING
FOR THE PAST MILLION YEARS,
AT LEAST.

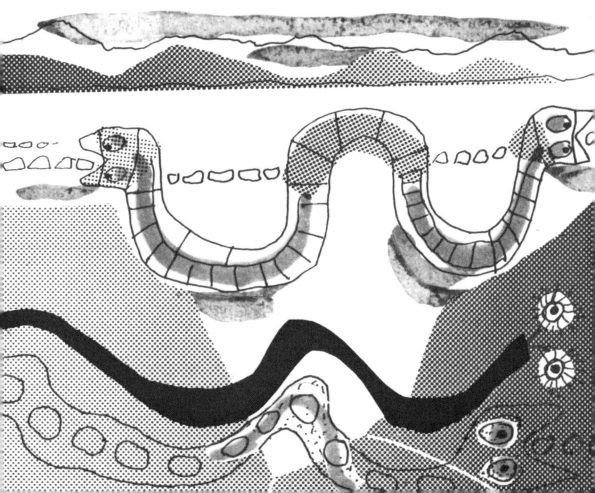

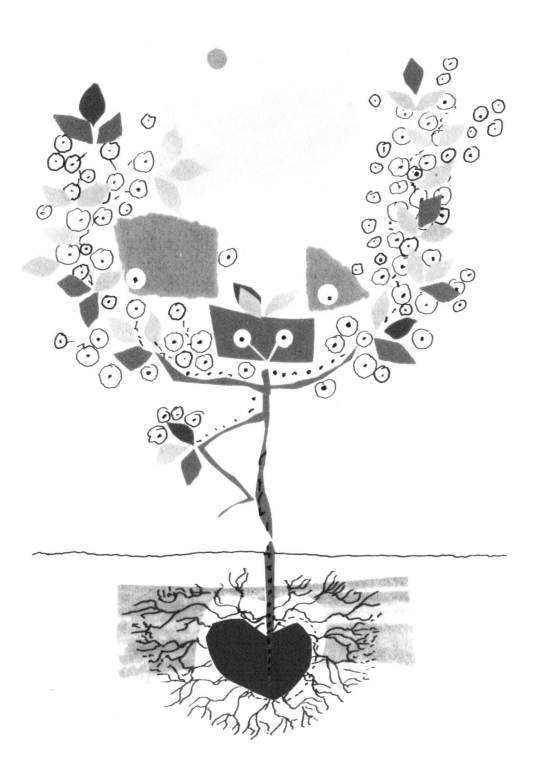

THIS LITTLE APPLE TREE

THIS LITTLE APPLE TREE,
GNAWED ON IN WINTER BY HUNGRY MICE,
SHOULD HAVE GIVEN UP LONG AGO
IF IT HAD ANY COMMON SENSE.
YET IT KEEPS BLOOMING, TOP TO TOE.
FOR IT HAS ONLY APPLE-TREE SENSE,

POOR DEAR.

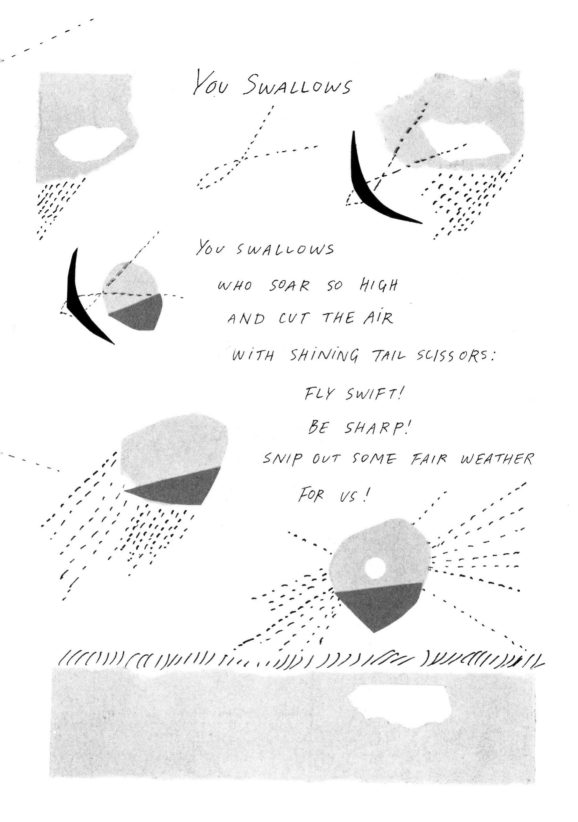

You Swallows

You swallows
who soar so high
and cut the air
with shining tail scissors:
Fly swift!
Be sharp!
Snip out some fair weather
for us!

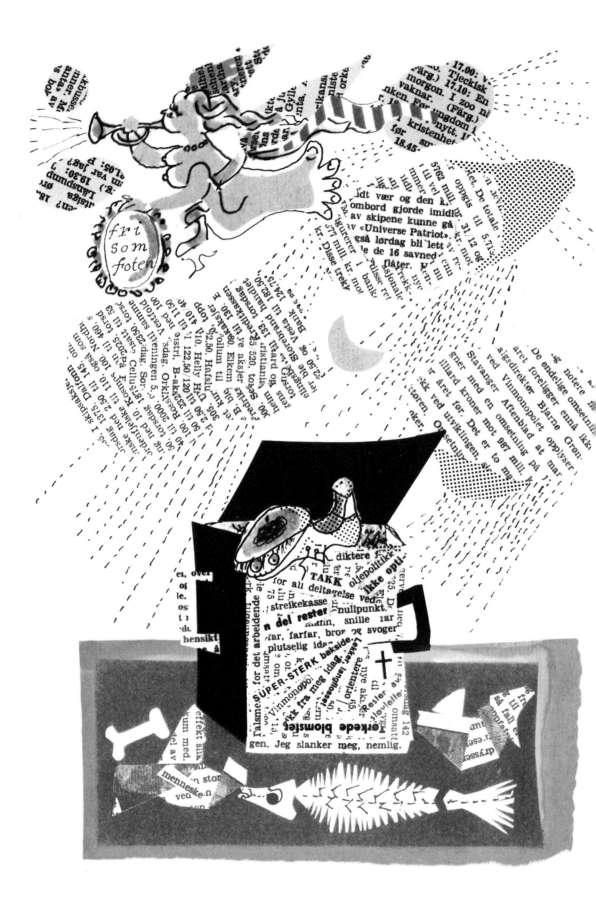

TATTERED SHOE

IT'S ALL SO SAD,
SIGHS THE **S**HOE
LYING IN THE TRASH.
I AM TATTERED,
I HAVE LOST MY FOOT
AND I AM A **L**EFTY TO BOOT.

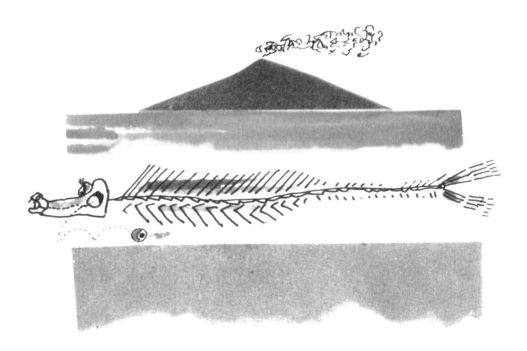

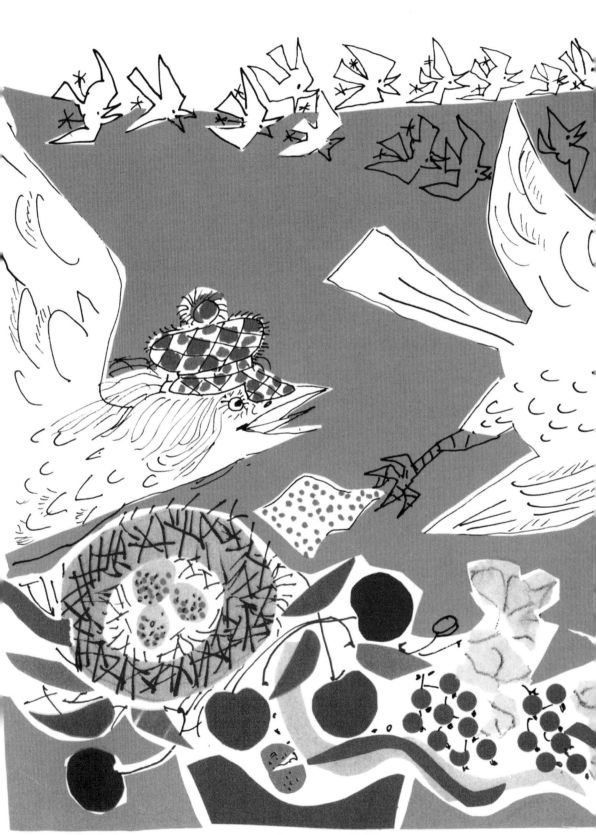

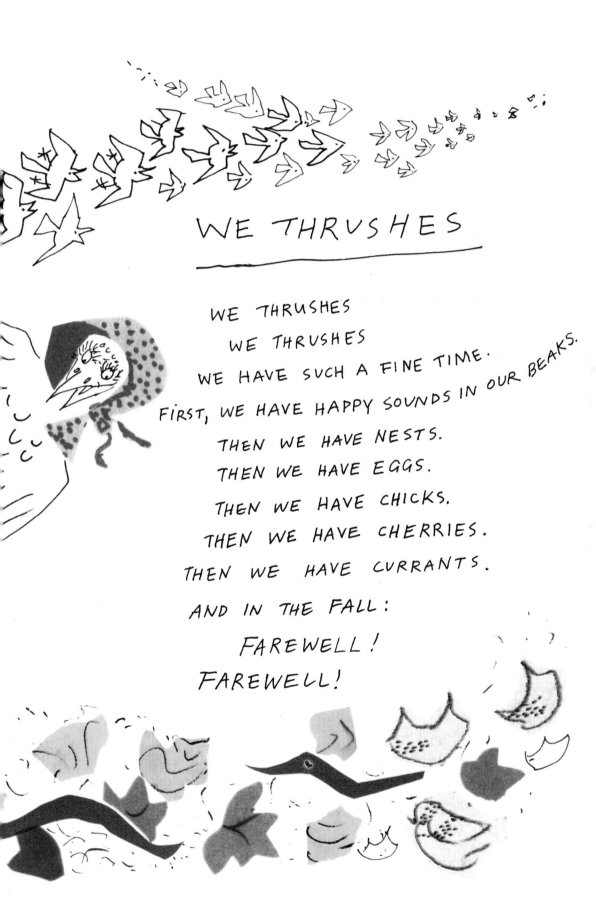

WE THRUSHES

WE THRUSHES
 WE THRUSHES
WE HAVE SUCH A FINE TIME.
FIRST, WE HAVE HAPPY SOUNDS IN OUR BEAKS.
 THEN WE HAVE NESTS.
 THEN WE HAVE EGGS.
 THEN WE HAVE CHICKS.
 THEN WE HAVE CHERRIES.
THEN WE HAVE CURRANTS.

AND IN THE FALL:
 FAREWELL!
FAREWELL!

LATE LAST NiGHT

LATE LAST NiGHT
AN OBLONG CREATURE,
BULGiNG YELLOW
WiTH GREEN SiLK WiNGS
AND MANY SPiNDLY LEGS,
FLEW AT THE LiGHT
OVER MY BED.

DANGEROUS?
NO.

iT WAS TOO SMALL TO FEAR

 SO

 i SiMPLY

 PULLED

 THE COVERS

 OVER MY HEAD.

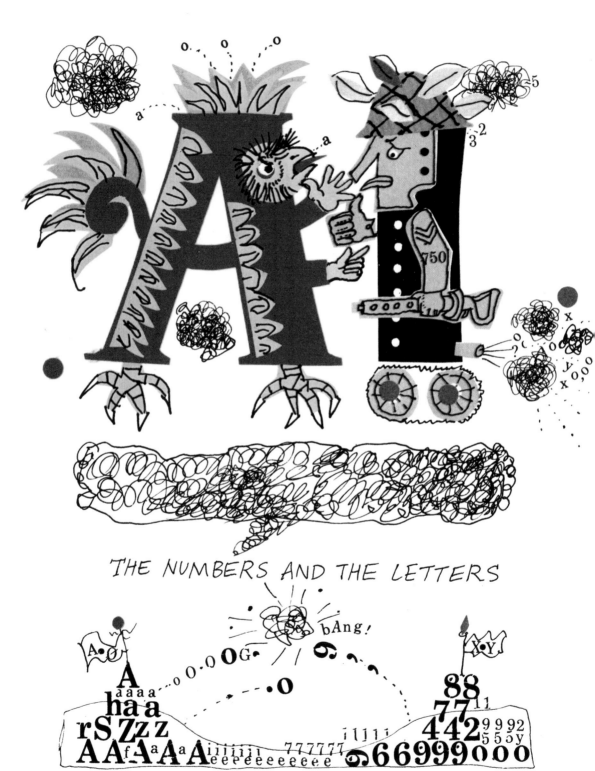

THE NUMBERS AND THE LETTERS

THE NUMBERS AND THE LETTERS
MET ONE DAY
TO FIGHT.
WE ALWAYS WIN,
SAID THE NUMBERS.
WE NEVER GIVE UP,
SAID THE LETTERS.
AND SO THEY LAY SCATTERED,
HELTER – SKELTER.

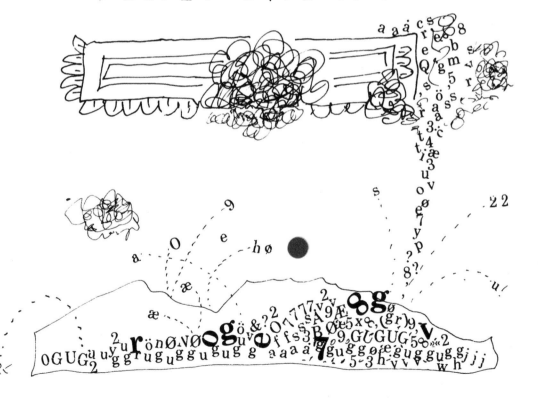

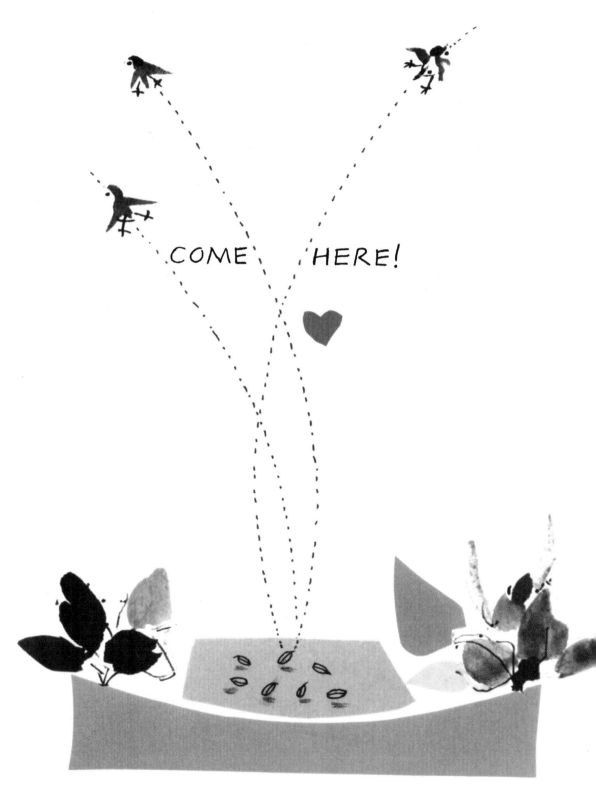

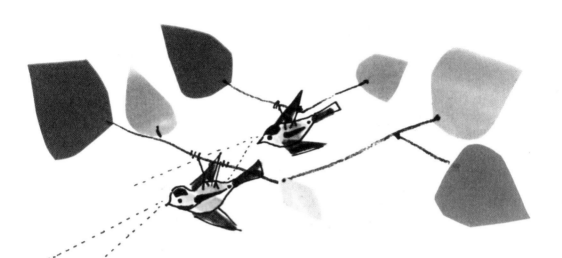

COME HERE, SMALL WARBLERS!
COME HERE, WE HAVE SOME FOOD FOR YOU.

DON'T BE AFRAID

WE WON'T EAT YOU
UNLESS WE ABSOLUTELY MUST.
AND EVEN THEN, WE'D HARDLY BE ABLE TO
CATCH YOU!

IT IS ODD.

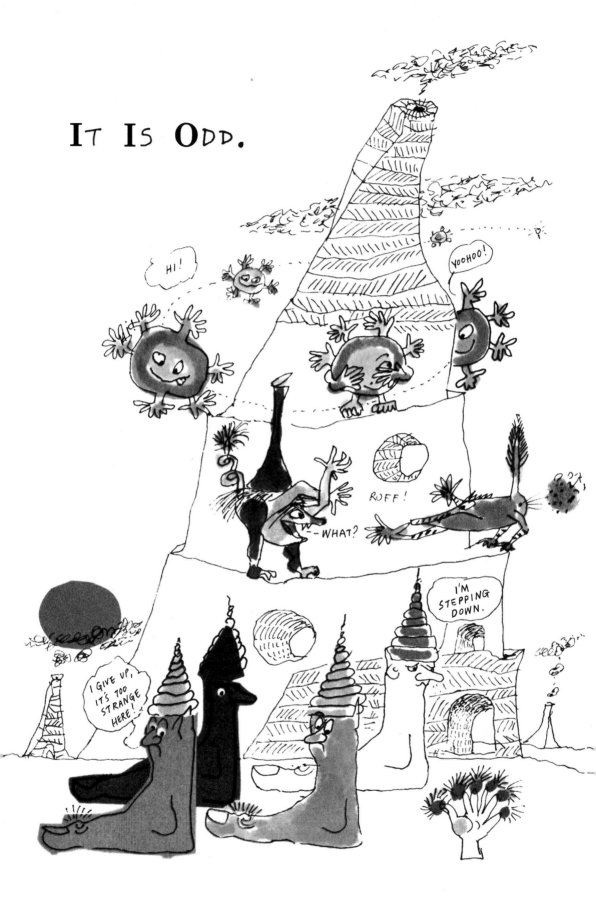

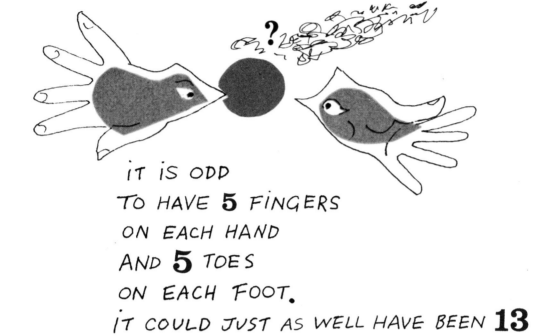

IT IS ODD
TO HAVE **5** FINGERS
ON EACH HAND
AND **5** TOES
ON EACH FOOT.
IT COULD JUST AS WELL HAVE BEEN **13**
OR **30**
ALL TOGETHER.
YET I HAPPEN TO HAVE
20.

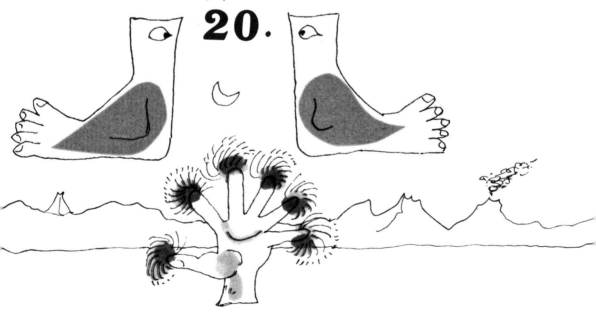

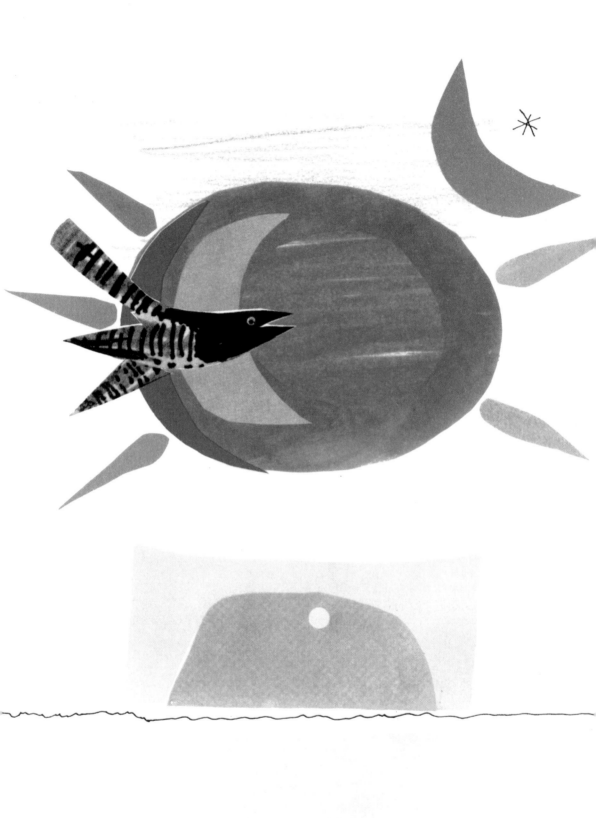

THE CUCKOO

YOU

WHO ARE LONGING AND ALOOF

MIDSUMMER AND SOLITUDE

SUMMER AND FALL

ALL AT ONCE:

LET ME CHANCE

BENEATH YOUR WISHING TREE

AND

WISH!

Inger Hagerup (1905-1985) made her literary debut in 1939 with the poetry collection *I Got Lost in the Woods*. Her later poems for children are classics in Norwegian children's literature. Hagerup also composed radio plays and reinterpreted Shakespeare and Goethe. She published multiple memoirs in the 1960's. Above all a poet of love, Hagerup's poetry also touches on themes of nature, death, and feminism and was greatly influenced by her involvement in the Norwegian resistance against the Nazis during World War II.

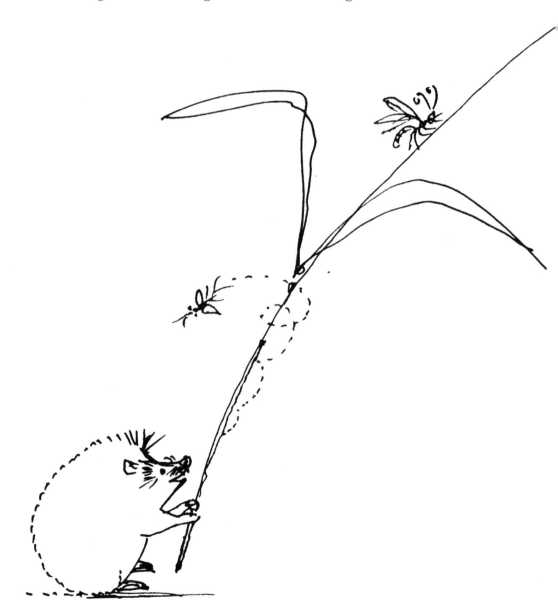

Paul René Gauguin (1911-1976) was born in Copenhagen, the son of Pola Gauguin and the grandson of the French post-impressionist Paul Gauguin. A painter, sculptor, set designer, and illustrator, he is well remembered for his innovative color woodcuts. He first learned wood cutting techniques while on fishing trips in Ibiza and Mallorca. His art draws inspiration from Max Ernst, Georges Braque, and Guillaume Apollinaire.

Becky Lynn Crook is a writer and literary translator. In 2010, she founded *SAND*, an English literary journal in Berlin. She began translating literature while living in the Netherlands. Her translations have appeared in *Granta*, *Guernica*, and *Freeman's*, and she is working on writing her own first novel. After coming across Inger Hagerup's children's poems in 2011, she was inspired to introduce the poems to international readers. She currently lives on Bainbridge Island, Washington, with her husband, daughter, and cat, Momo.

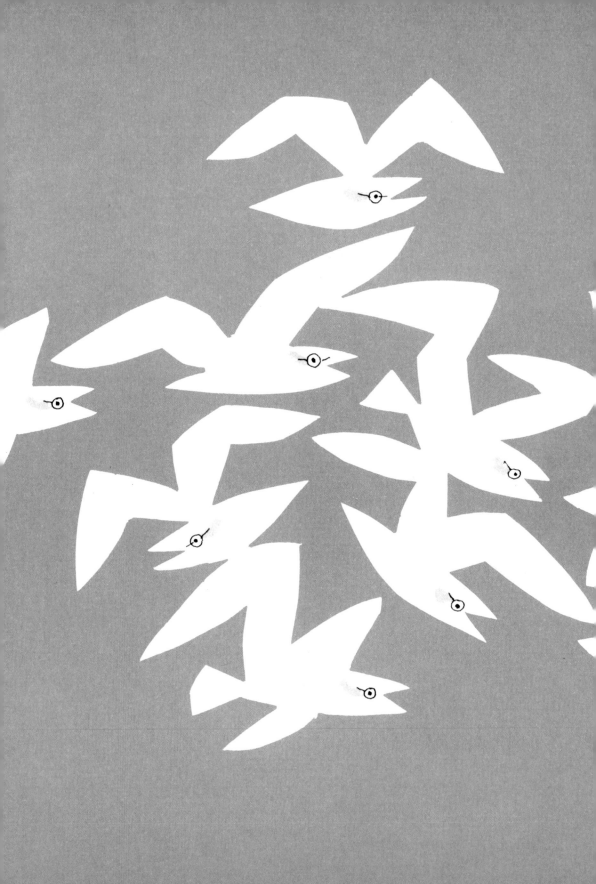